2012 DIARY

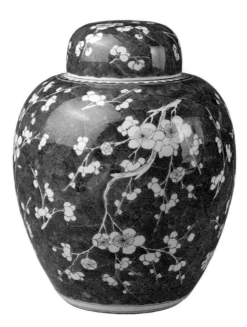

F

FRANCES LINCOLN LIMITED
PUBLISHERS

CREATED.

Supporting the world's leading
museum of art and design
the Victoria and Albert
Museum, London

V&A

Frances Lincoln Limited
4 Torriano Mews
Torriano Avenue
London NW5 2RZ
www.franceslincoln.com

A catalogue record for this book is available from
the British Library

ISBN: 978-0-7112-3199-3

Printed in China

First Frances Lincoln edition 2011

9 8 7 6 5 4 3 2 1

FRONT COVER: *Pavonia,* Frederic Leighton, 1858–59. Private
collection c/o Christie's.

BACK COVER: *Hera,* roller-printed cotton, Arthur Silver for
Liberty & Co., Rossendale Printing Co., 1887

TITLE PAGE: Ginger jar, porcelain, decorated in underglaze
cobalt blue, Kangxi period, 1683–1710

INTRODUCTION: *Jasmine* wallpaper, William Morris, block-
printed in distemper colours, 1872

VISITORS' INFORMATION

Victoria and Albert Museum
Cromwell Road
South Kensington, London SW7 2RL
Telephone: 020 7942 2000

Museum hours of opening:
10.00 to 17.45 daily
10.00 to 22.00 Fridays (selected galleries remain open
after 18.00)
Closed: Christmas Eve, Christmas Day and Boxing Day

For information on the V&A Museum, please visit the
website at www.vam.ac.uk

For information on V&A-inspired products, please visit the
V&A Shop website at www.vandashop.co.uk

For information on V&A Membership, please contact the
Members' Office on 020 7942 2271.

CALENDAR 2012

JANUARY	FEBRUARY	MARCH	APRIL	MAY	JUNE
M T W T F S S	M T W T F S S	M T W T F S S	M T W T F S S	M T W T F S S	M T W T F S S
1	1 2 3 4 5	1 2 3 4	1	1 2 3 4 5 6	1 2 3
2 3 4 5 6 7 8	6 7 8 9 10 11 12	5 6 7 8 9 10 11	2 3 4 5 6 7 8	7 8 9 10 11 12 13	4 5 6 7 8 9 10
9 10 11 12 13 14 15	13 14 15 16 17 18 19	12 13 14 15 16 17 18	9 10 11 12 13 14 15	14 15 16 17 18 19 20	11 12 13 14 15 16 17
16 17 18 19 20 21 22	20 21 22 23 24 25 26	19 20 21 22 23 24 25	16 17 18 19 20 21 22	21 22 23 24 25 26 27	18 19 20 21 22 23 24
23 24 25 26 27 28 29	27 28 29	26 27 28 29 30 31	23 24 25 26 27 28 29	28 29 30 31	25 26 27 28 29 30
30 31			30		

JULY	AUGUST	SEPTEMBER	OCTOBER	NOVEMBER	DECEMBER
M T W T F S S	M T W T F S S	M T W T F S S	M T W T F S S	M T W T F S S	M T W T F S S
1	1 2 3 4 5	1 2	1 2 3 4 5 6 7	1 2 3 4	1 2
2 3 4 5 6 7 8	6 7 8 9 10 11 12	3 4 5 6 7 8 9	8 9 10 11 12 13 14	5 6 7 8 9 10 11	3 4 5 6 7 8 9
9 10 11 12 13 14 15	13 14 15 16 17 18 19	10 11 12 13 14 15 16	15 16 17 18 19 20 21	12 13 14 15 16 17 18	10 11 12 13 14 15 16
16 17 18 19 20 21 22	20 21 22 23 24 25 26	17 18 19 20 21 22 23	22 23 24 25 26 27 28	19 20 21 22 23 24 25	17 18 19 20 21 22 23
23 24 25 26 27 28 29	27 28 29 30 31	24 25 26 27 28 29 30	29 30 31	26 27 28 29 30	24 25 26 27 28 29 30
30 31					31

CALENDAR 2013

JANUARY	FEBRUARY	MARCH	APRIL	MAY	JUNE
M T W T F S S	M T W T F S S	M T W T F S S	M T W T F S S	M T W T F S S	M T W T F S S
1 2 3 4 5 6	1 2 3	1 2 3	1 2 3 4 5 6 7	1 2 3 4 5	1 2
7 8 9 10 11 12 13	4 5 6 7 8 9 10	4 5 6 7 8 9 10	8 9 10 11 12 13 14	6 7 8 9 10 11 12	3 4 5 6 7 8 9
14 15 16 17 18 19 20	11 12 13 14 15 16 17	11 12 13 14 15 16 17	15 16 17 18 19 20 21	13 14 15 16 17 18 19	10 11 12 13 14 15 16
21 22 23 24 25 26 27	18 19 20 21 22 23 24	18 19 20 21 22 23 24	22 23 24 25 26 27 28	20 21 22 23 24 25 26	17 18 19 20 21 22 23
28 29 30 31	25 26 27 28	25 26 27 28 29 30 31	29 30	27 28 29 30 31	24 25 26 27 28 29 30

JULY	AUGUST	SEPTEMBER	OCTOBER	NOVEMBER	DECEMBER
M T W T F S S	M T W T F S S	M T W T F S S	M T W T F S S	M T W T F S S	M T W T F S S
1 2 3 4 5 6 7	1 2 3 4	1	1 2 3 4 5 6	1 2 3	1
8 9 10 11 12 13 14	5 6 7 8 9 10 11	2 3 4 5 6 7 8	7 8 9 10 11 12 13	4 5 6 7 8 9 10	2 3 4 5 6 7 8
15 16 17 18 19 20 21	12 13 14 15 16 17 18	9 10 11 12 13 14 15	14 15 16 17 18 19 20	11 12 13 14 15 16 17	9 10 11 12 13 14 15
22 23 24 25 26 27 28	19 20 21 22 23 24 25	16 17 18 19 20 21 22	21 22 23 24 25 26 27	18 19 20 21 22 23 24	16 17 18 19 20 21 22
29 30 31	26 27 28 29 30 31	23 24 25 26 27 28 29	28 29 30 31	25 26 27 28 29 30	23 24 25 26 27 28 29
		30			30 31

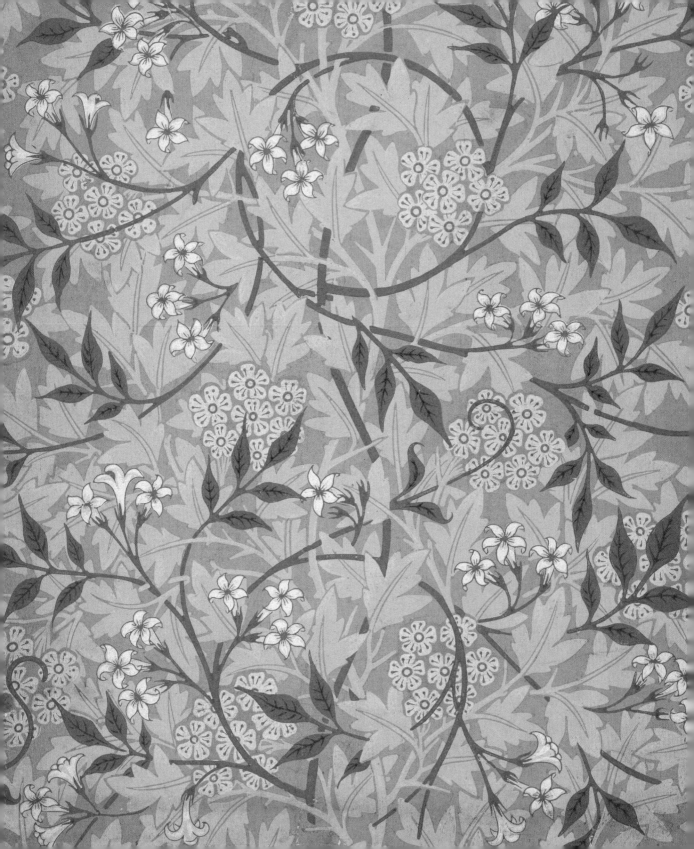

INTRODUCTION

One clear and revolutionary ideal emerged from the confusion of styles and theories that bedevilled the world of art and design in the middle years of the nineteenth century in Britain: the desire to escape the ugliness and materialism of the age and find a new Beauty. The Aesthetic Movement, as it came to be known, sought nothing less than the creation of a new kind of art, set free from outworn establishment ideas and Victorian notions of morality. This was to be 'Art for Art's sake' – art that existed only in order to be beautiful; pictures that did not tell stories or make moral points; sculptures that simply offered visual and tactile delight and dared to hint at sensual pleasures.

The same daring spirit motivated innovation in design. Avant-garde architects and designers such as E. W. Godwin and Christopher Dresser transformed the banal and pretentious furnishings of the middle-class home. With a refined sensibility to line and form and an unprecedented feeling for colour, their aim was to make chairs and tables worthy of the name 'Art Furniture' and to create ceramics, textiles, wallpapers and other manufactures exquisite enough for the houses of Aesthetes.

In the 1860s and '70s a new and exciting 'Cult of Beauty' united, for a while at least, romantic bohemians such as Dante Gabriel Rossetti and his younger Pre-Raphaelite followers William Morris and Edward Burne-Jones, maverick figures such as James McNeill Whistler and Albert Moore, and the 'Olympians' – the painters of grand classical subjects who belonged to the circle of Frederic Leighton and G. F. Watts. Choosing unconventional models, such as Rossetti's muse Jane Morris, these painters created an entirely new type of female beauty.

Rossetti and his friends were also the first to attempt to realise their imaginative world in the creation of 'artistic' furniture and the decoration of rooms. The rise of Aestheticism in painting was paralleled in the decorative arts by a new and increasingly widespread interest in the decoration of houses. Many of the key avant-garde architects and designers interested themselves not only in working for wealthy clients but also in the reform of design for the middle-class home. As a result, the notion of 'the House Beautiful' became a touchstone of cultured life.

Attracted by the growing popularity of Aesthetic ideas, many of the leading firms making furniture, ceramics, domestic metalwork and textiles courted artists such as Walter Crane and a growing band of professional designers such as Christopher Dresser and Bruce Talbert. Coinciding with a period of unprecedented expansion of domestic markets, the styles favoured by Aesthetic designers were among the very first to be exploited and disseminated widely through commercial enterprise.

By the 1880s Britain was in the grip of the 'greenery-yallery' Aesthetic Craze, lovingly satirised by Gilbert and Sullivan in their famous comic opera *Patience* and by the caricaturist George du Maurier in the pages of *Punch*. Oscar Wilde invented a brilliant – and much parodied – pose of 'poetic intensity', but also through his promotion of Aesthetic ideals of the 'House Beautiful' made himself the first celebrity style guru. By the last decade of Queen Victoria's reign the Aesthetic Movement had entered its final, fascinating Decadent phase, characterised by the extraordinary black-and-white drawings of Aubrey Beardsley in *The Yellow Book*.

Stephen Calloway
Curator
The Cult of Beauty: The Aesthetic Movement in Britain 1860–1900

DECEMBER · JANUARY 2012

26 Monday

Boxing Day (St Stephen's Day)
Holiday UK, Republic of Ireland, USA, Canada,
Australia and New Zealand

27 Tuesday

Holiday, UK, Australia and New Zealand

28 Wednesday

29 Thursday

30 Friday

31 Saturday

New Year's Eve

1 Sunday

First Quarter
New Year's Day
Holiday, Republic of Ireland

The Toilette of Salome, Aubrey Beardsley, line block print, ink on paper, 1894

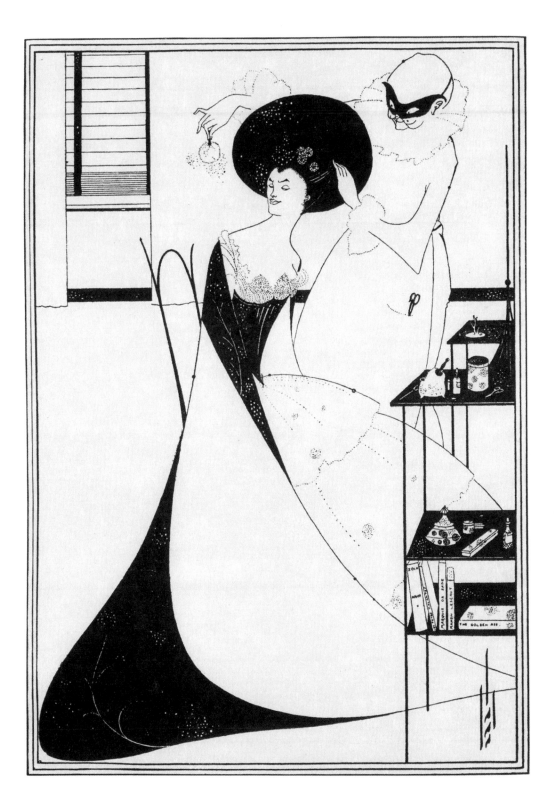

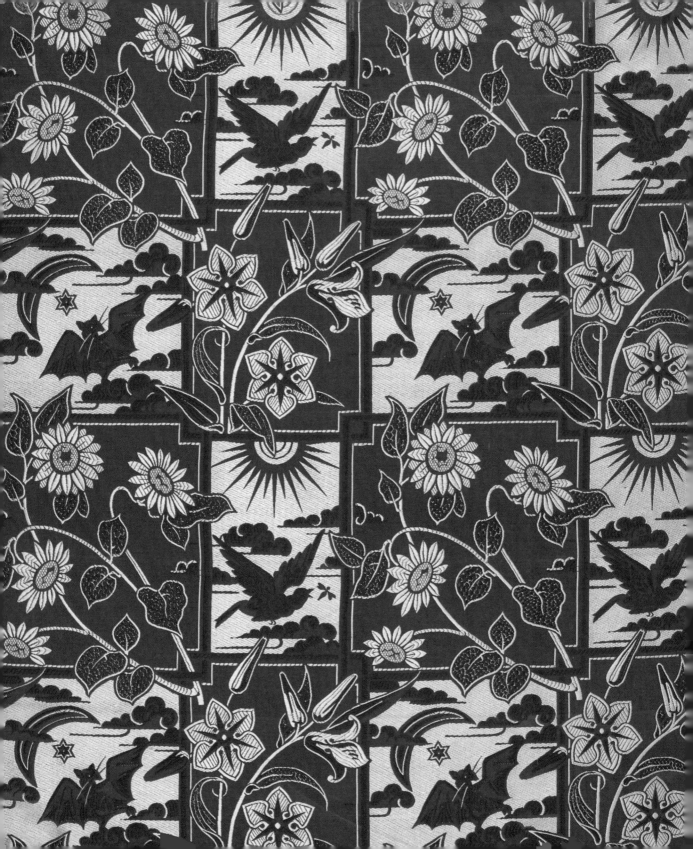

JANUARY

2 Monday Holiday, UK, USA, Canada, Australia and New Zealand

3 Tuesday Holiday, Scotland and New Zealand

4 Wednesday

5 Thursday

6 Friday Epiphany

7 Saturday

8 Sunday

Bat furnishing fabric, George Haité, figured satin for Daniel Walters & Sons, about 1880

JANUARY

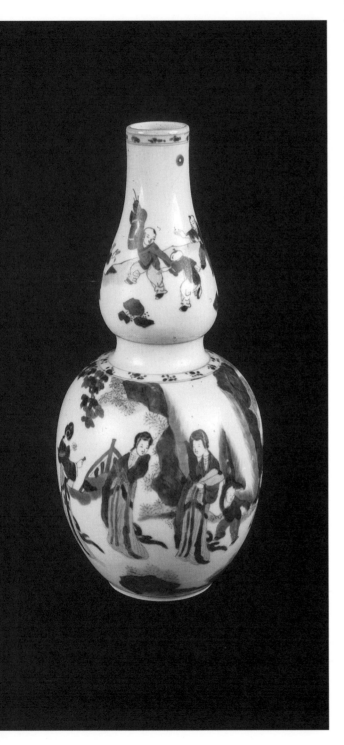

10 Tuesday

11 Wednesday

12 Thursday

Double-gourd-shaped vase from Rossetti's collection.
Porcelain decorated in underglaze cobalt blue, Kangxi
period, 1662–1722.

13 Friday

14 Saturday

15 Sunday

Ginger jar from Whistler's collection. Porcelain decorated in underglaze cobalt blue, Kangxi period, 1662–1722.

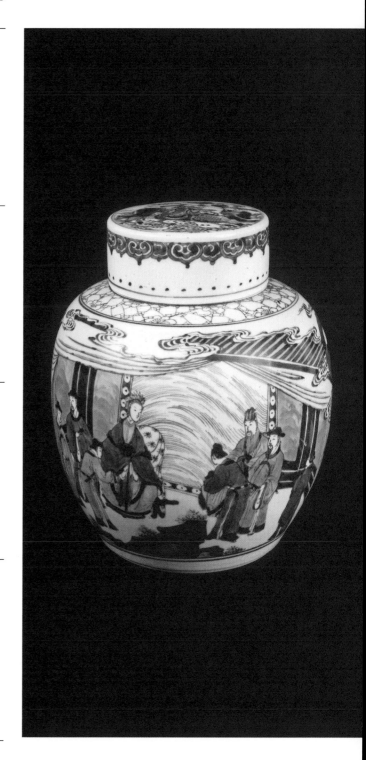

JANUARY

16 Monday

Last Quarter
Holiday, USA (Martin Luther King's Birthday)

17 Tuesday

18 Wednesday

19 Thursday

20 Friday

21 Saturday

22 Sunday

An Open Book (study for *Reading Aloud*), Albert Moore, watercolour on paper, 1883–4

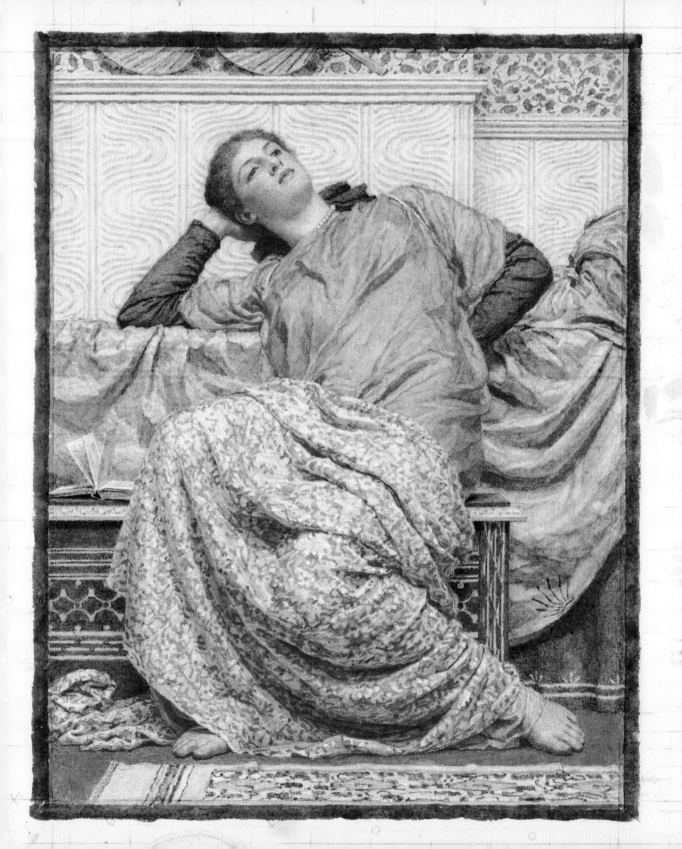

JANUARY

23 Monday

24 Tuesday

25 Wednesday

26 Thursday

Holiday, Australia (Australia Day)

27 Friday

28 Saturday

29 Sunday

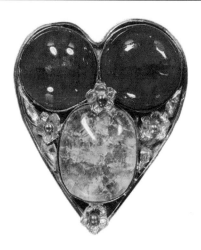

Brooch, silver set with glass, 1840–65

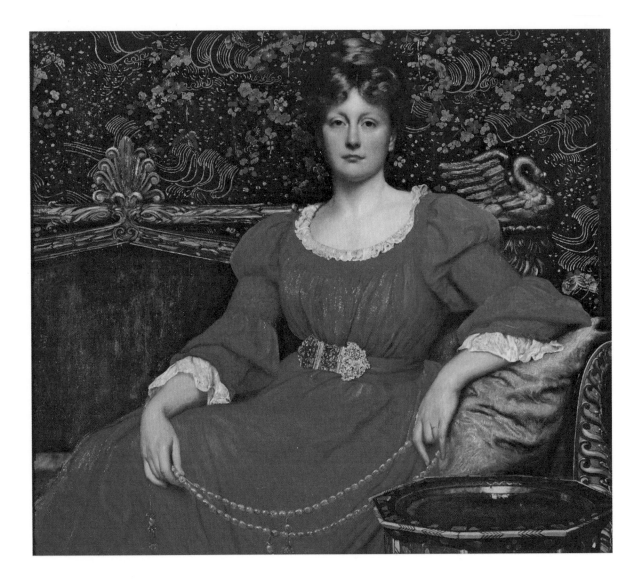

30 Monday

31 Tuesday
First Quarter

1 Wednesday

2 Thursday

3 Friday

4 Saturday

5 Sunday

Mrs Luke Ionides, William Blake Richmond, oil on canvas, 1882

FEBRUARY

6 Monday

Accession of Queen Elizabeth II (Diamond Jubilee)
Holiday, New Zealand (Waitangi Day)

7 Tuesday

Full Moon

8 Wednesday

9 Thursday

10 Friday

11 Saturday

12 Sunday

Stained-glass panel, probably designed by Carl Almquist and made by Shrigley and Hunt, about 1886

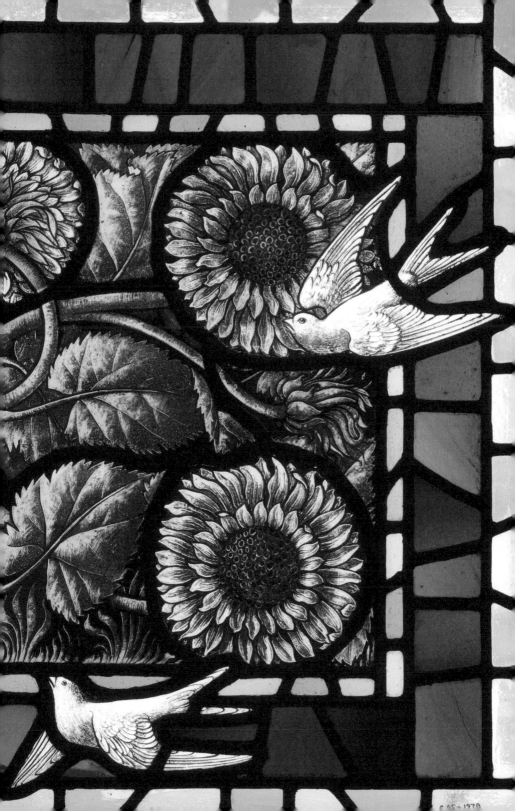

FEBRUARY

13 Monday

14 Tuesday *Last Quarter*
St Valentine's Day

15 Wednesday

16 Thursday

Wallpaper panel, Christopher Dresser, colour print from
wood blocks, made by Jeffrey & Co., about 1875–8

17 Friday

18 Saturday

19 Sunday

Wallpaper panel, Bruce Talbert, colour print from wood
blocks, made by Jeffrey & Co., about 1877

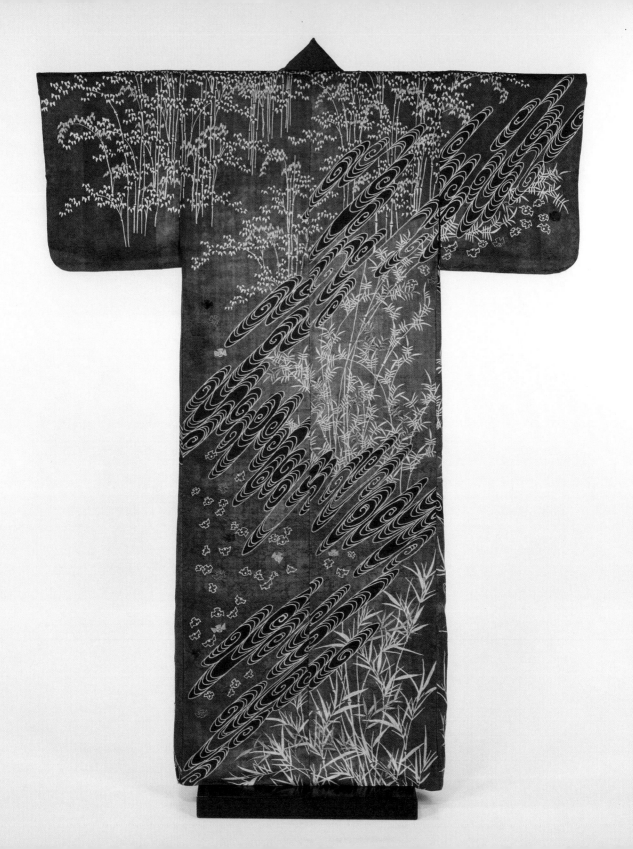

FEBRUARY

20 Monday

21 Tuesday

New Moon
Shrove Tuesday

22 Wednesday

Ash Wednesday

23 Thursday

24 Friday

25 Saturday

26 Sunday

Kimono with decoration of rippling water, bamboo and birds, purchased from Liberty. Monochrome figured satin silk with paste-resist decoration (*yuzen*) and embroidery in silk and metallic thread, 1860–90.

FEBRUARY • MARCH

27 Monday

28 Tuesday

29 Wednesday

1 Thursday *First Quarter*
 St David's Day

2 Friday

3 Saturday

4 Sunday

Plate, printed white earthenware made by
Brown-Westhead, Moore & Co., about 1875–85

MARCH

5 Monday

6 Tuesday

7 Wednesday

8 Thursday *Full Moon*

9 Friday

10 Saturday

11 Sunday

Photograph, *After the Manner of the Elgin Marbles*, Julia Margaret Cameron,
albumen print from wet collodion on glass negative, 1867

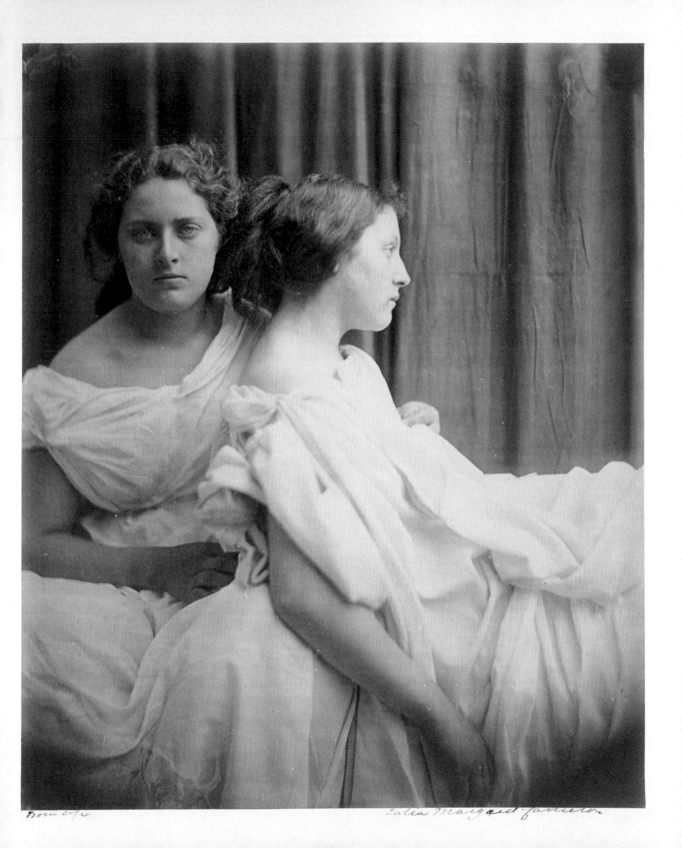

Julia Margaret Cameron

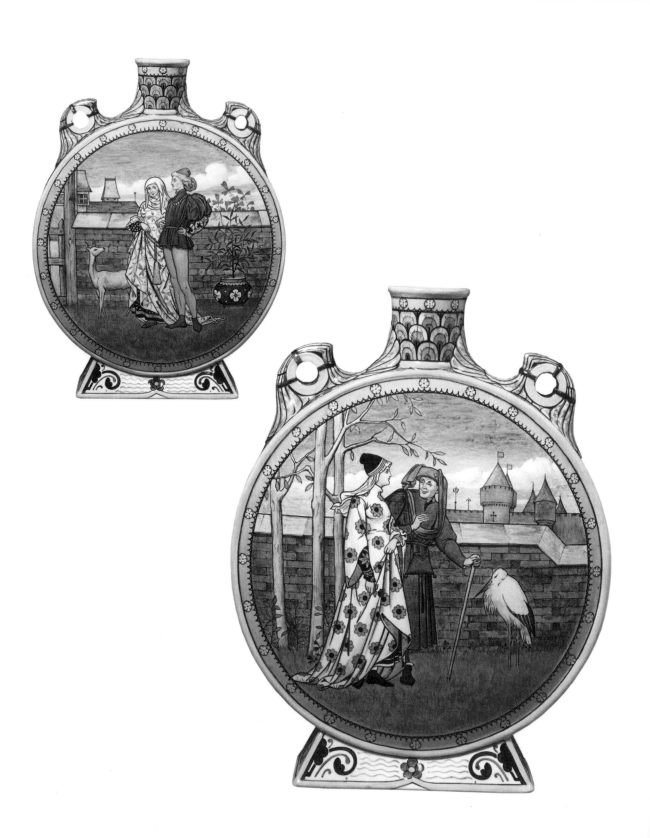

12 Monday Commonwealth Day

13 Tuesday

14 Wednesday

15 Thursday *Last Quarter*

16 Friday

17 Saturday St Patrick's Day
 Holiday, Republic of Ireland

18 Sunday Mother's Day, UK

A pair of pilgrim flasks, Henry Stacy Marks, earthenware with painted decoration, 1877

MARCH

19 Monday Holiday, Northern Ireland (St Patrick's Day)

20 Tuesday Vernal Equinox (Spring begins)

21 Wednesday

22 Thursday *New Moon*

23 Friday

24 Saturday

25 Sunday

British Summer Time begins

(Left and right) Design for a Brussels carpet, Walter Crane,
pencil and watercolour, about 1895

26 Monday

27 Tuesday

28 Wednesday

29 Thursday

30 Friday

First Quarter

31 Saturday

1 Sunday

Palm Sunday

Photograph, carte-de-visite, Oscar Wilde, W. & D. Downey, 1889

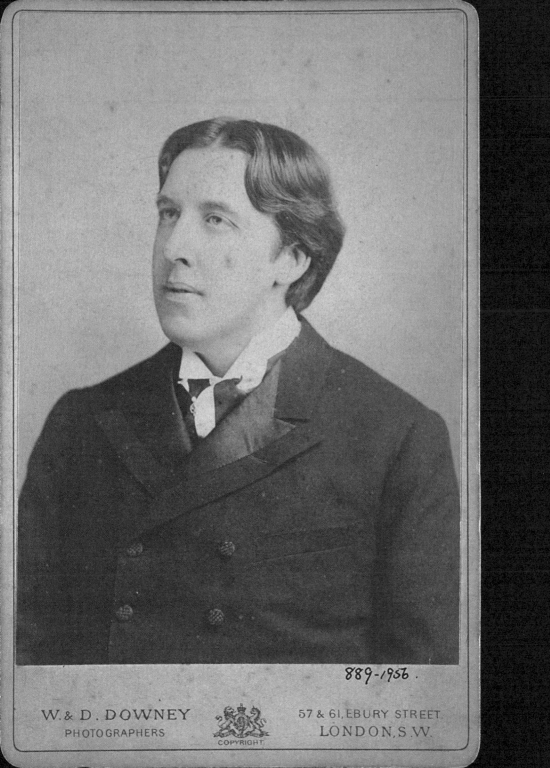

889-1956.

APRIL

2 Monday

3 Tuesday

4 Wednesday

5 Thursday Maundy Thursday

6 Friday

Full Moon
Good Friday
Holiday, UK, Canada, Australia and New Zealand

7 Saturday

Holiday, Australia (Easter Saturday)
First Day of Passover (Pesach)

8 Sunday Easter Sunday

Dish, William De Morgan, earthenware
with a lead glaze, about 1888

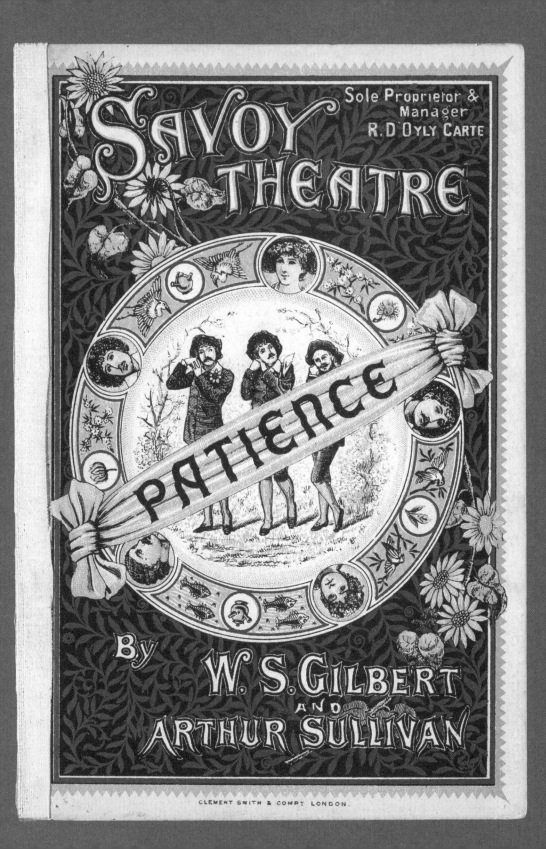

SAVOY THEATRE

Sole Proprietor &
Manager
R. D'Oyly Carte

PATIENCE

By
W. S. GILBERT
AND
ARTHUR SULLIVAN

CLEMENT SMITH & COMPY LONDON.

APRIL

9 Monday

Easter Monday
Holiday, UK (exc. Scotland), Republic of Ireland
Australia and New Zealand

10 Tuesday

11 Wednesday

12 Thursday

13 Friday

Last Quarter

14 Saturday

15 Sunday

Programme for Gilbert and Sullivan's *Patience*, lithograph, 1881

APRIL

16 Monday

17 Tuesday

18 Wednesday

19 Thursday

20 Friday

21 Saturday

New Moon
Birthday of Queen Elizabeth II

22 Sunday

Furnishing fabric, Bruce Talbert, woven silk damask for Warner & Ramm, about 1875

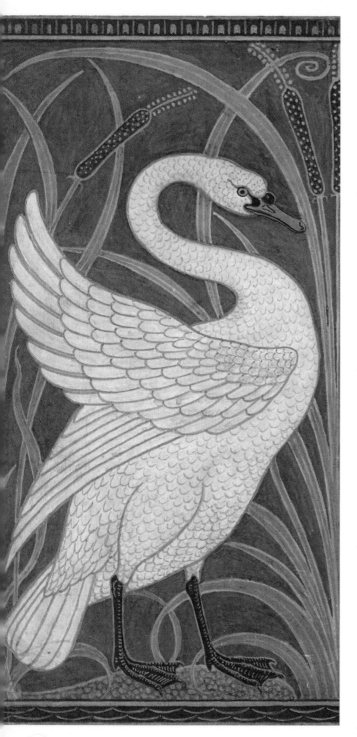

APRIL

23 Monday St George's Day

24 Tuesday

25 Wednesday Holiday, Australia and New Zealand
 (Anzac Day)

26 Thursday

27 Friday

28 Saturday

29 Sunday *First Quarter*

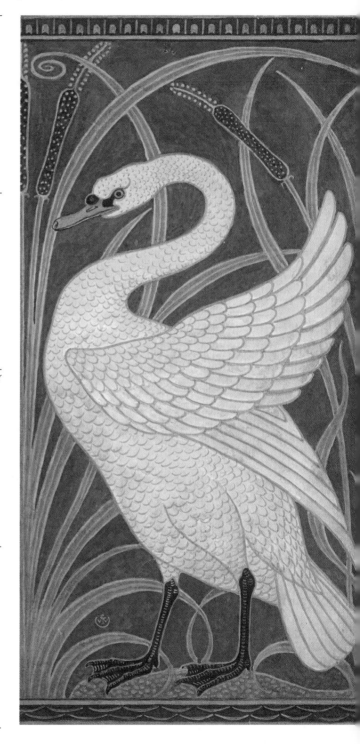

(Left and right) Design for *Swan, Rush and Iris* wallpaper
dado, Walter Crane, gouache and watercolour on paper, 1875

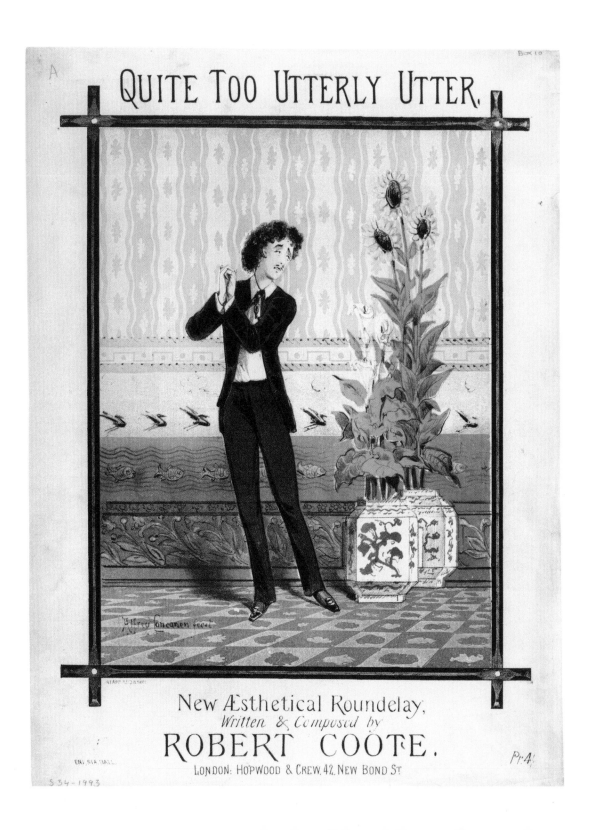

30 Monday

1 Tuesday

2 Wednesday

3 Thursday

4 Friday

5 Saturday

6 Sunday

Full Moon

'Quite Too Utterly Utter', song sheet cover, Alfred Concanen, colour lithograph, about 1881

MAY

7 Monday Early Spring Bank Holiday, UK and Republic of Ireland

8 Tuesday

9 Wednesday

10 Thursday

11 Friday

12 Saturday *Last Quarter*

13 Sunday Mother's Day, USA, Canada,
 Australia and New Zealand

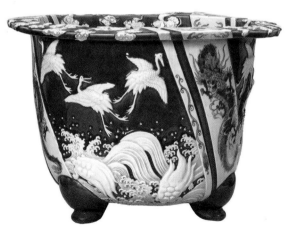

Flying Crane flowerpot (*jardinière*),
glazed porcelain, 1860–2

MAY

14 Monday

15 Tuesday

16 Wednesday

17 Thursday Ascension Day

18 Friday

19 Saturday

20 Sunday *New Moon*

The Hay Field, Thomas Armstrong, oil on canvas, 1869

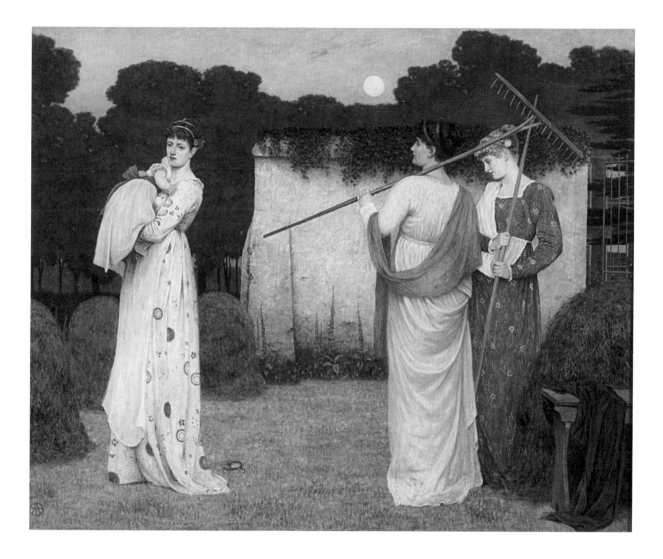

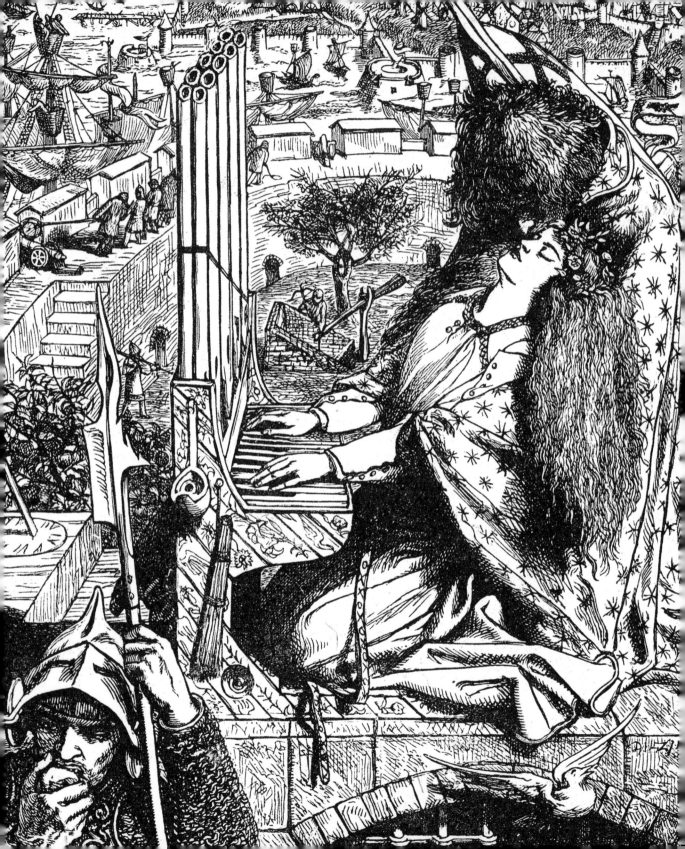

MAY

21 Monday Holiday, Canada (Victoria Day)

22 Tuesday

23 Wednesday

24 Thursday

25 Friday

26 Saturday

27 Sunday Whit Sunday (Pentecost)
Feast of Weeks (Shavuot)

Book illustration, *The Palace of Art: St Cecilia*, Dante Gabriel Rossetti. Engraved by the Dalziel Brothers for *The Moxon Tennyson*, 1857.

MAY • JUNE

28 Monday

First Quarter
Holiday, USA (Memorial Day)

29 Tuesday

30 Wednesday

31 Thursday

1 Friday

2 Saturday Coronation Day

3 Sunday Trinity Sunday

(Left and right) *Apple Blossom* wallpaper, Lewis F. Day, colour
print from wood blocks, made by Jeffrey & Co., 1874

JUNE

4 Monday

Full Moon
Spring Bank Holiday, UK
Holiday, Republic of Ireland
Holiday, New Zealand (The Queen's Birthday)

5 Tuesday

Holiday, UK (The Queen's Diamond Jubilee)

6 Wednesday

7 Thursday

Corpus Christi

8 Friday

9 Saturday

The Queen's Official Birthday (subject to confirmation)

10 Sunday

The China Cabinet at Knole, Ellen L. Clacy, watercolour, about 1880

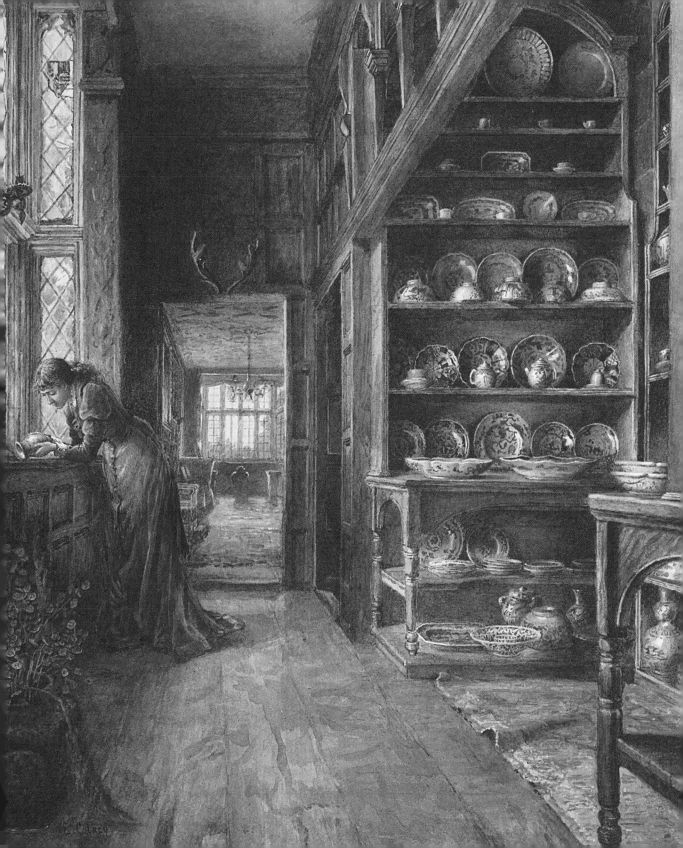

JUNE

11 Monday

Last Quarter
Holiday, Australia (The Queen's Birthday), subject to confirmation

12 Tuesday

13 Wednesday

14 Thursday

15 Friday

16 Saturday

17 Sunday Father's Day, UK, Canada and USA

Teapot, Christopher Dresser, electroplated nickel silver with
ebony handle, made by James Dixon & Sons, about 1879

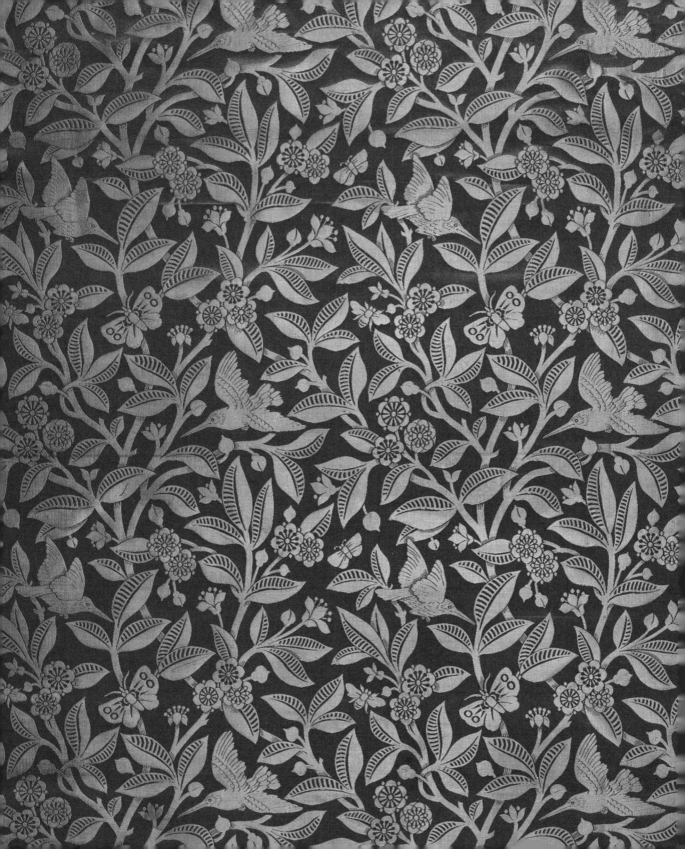

JUNE

18 Monday

19 Tuesday *New Moon*

20 Wednesday Summer Solstice (Summer begins)

21 Thursday

22 Friday

23 Saturday

24 Sunday

Kingfisher furnishing fabric, Bruce Talbert, woven silk damask for Warner & Ramm, about 1875

JUNE • JULY

25 Monday

26 Tuesday

27 Wednesday *First Quarter*

28 Thursday

29 Friday

30 Saturday

1 Sunday Canada Day, Canada

Screen, W. E. Nesfield. Ebonized wood, with fretwork and gilding,
and six panels of Japanese paper, made by James Forsythe, 1867.

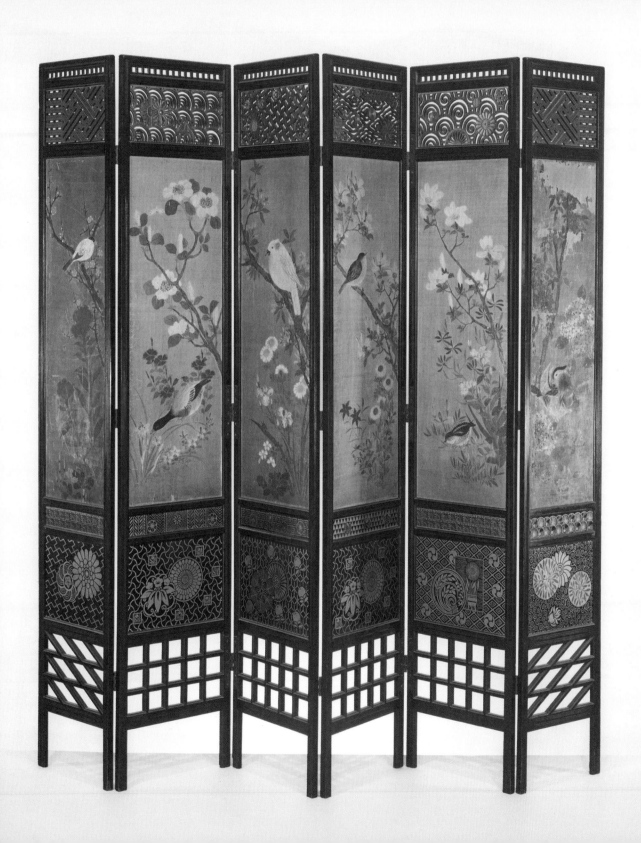

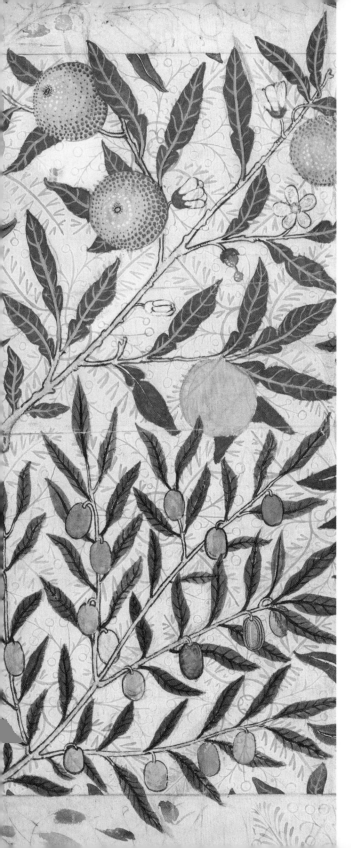

JULY

2 Monday Holiday, Canada (Canada Day)

3 Tuesday *Full Moon*

4 Wednesday Holiday, USA (Independence Day)

5 Thursday

6 Friday

7 Saturday

8 Sunday

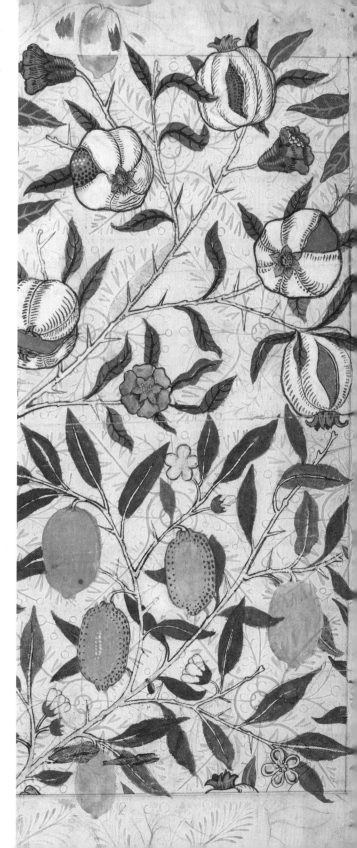

(Left and right) Design for *Fruit/Pomegranate* wallpaper, William Morris, pencil, pen and ink, watercolour and body colour on paper, 1862

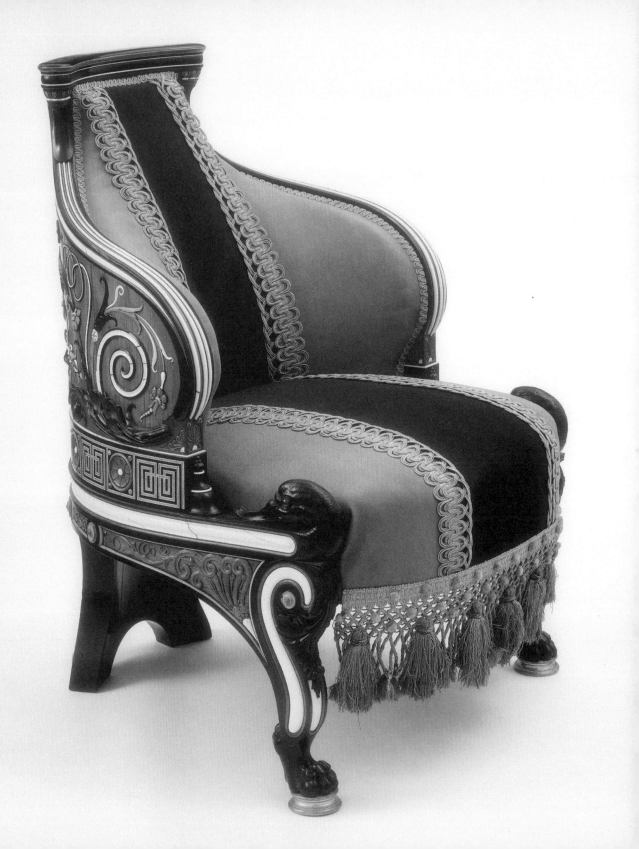

9 Monday

10 Tuesday

11 Wednesday *Last Quarter*

12 Thursday Holiday, Northern Ireland
 (Battle of the Boyne)

13 Friday

14 Saturday

15 Sunday St Swithin's Day

Chair from Marquand suite, Sir Lawrence Alma-Tadema, carved mahogany with cedar and ebony veneer and inlay of several woods, ivory and abalone shell, about 1884–6

JULY

16 Monday

17 Tuesday

18 Wednesday

19 Thursday *New Moon*

20 Friday

21 Saturday

22 Sunday

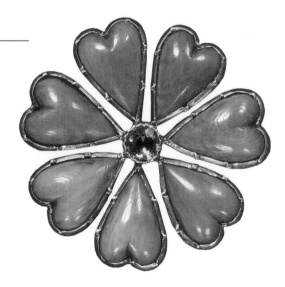

Brooch, Edward Burne-Jones, about 1890

23 Monday

24 Tuesday

25 Wednesday

26 Thursday

First Quarter

27 Friday

28 Saturday

29 Sunday

Pomona tapestry, Edward Burne-Jones and John H. Dearle for Morris & Co., woven wool and silk on a cotton warp, 1900

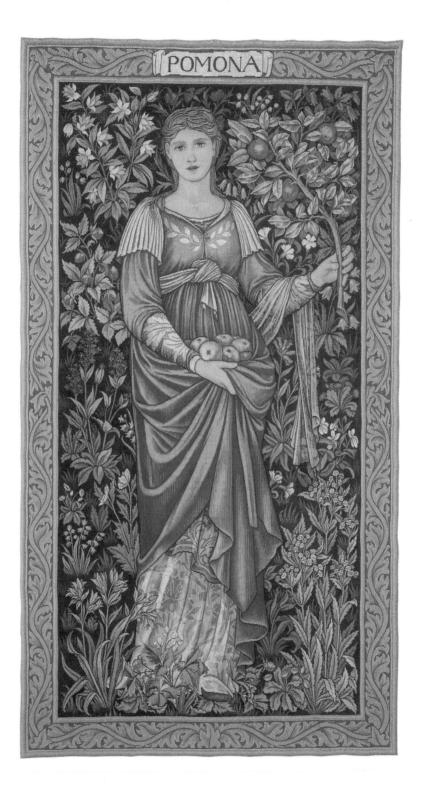

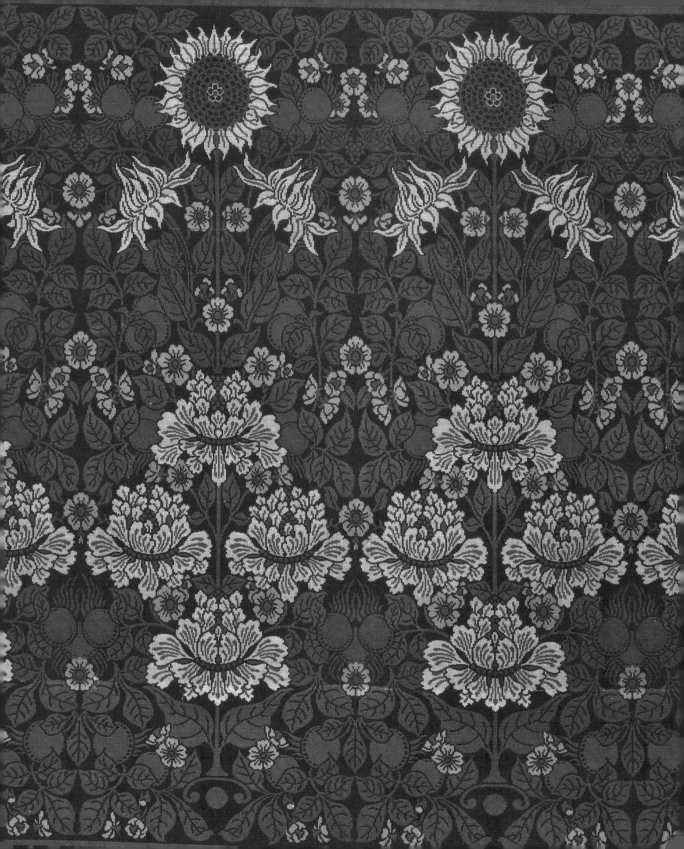

30 Monday

31 Tuesday

1 Wednesday

2 Thursday

Full Moon

3 Friday

4 Saturday

5 Sunday

Curtains, Bruce Talbert, jacquard-woven silk and wool, made by James Templeton & Co., 1878–80

AUGUST

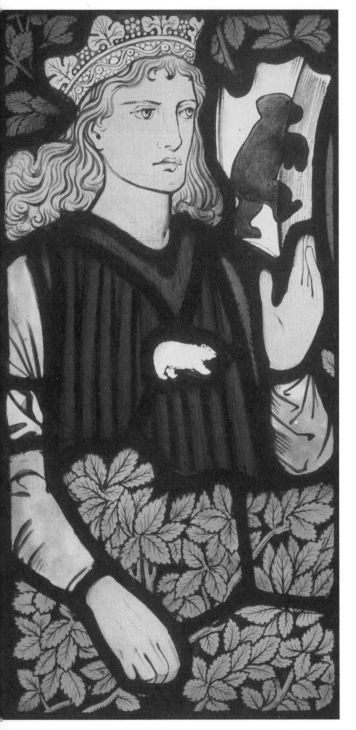

6 Monday

Summer Bank Holiday, Scotland
Holiday, Republic of Ireland

7 Tuesday

8 Wednesday

9 Thursday

Last Quarter

The Prince, Edward Burne-Jones, stained and painted glass, made by Morris, Marshall, Faulkner & Co., about 1864

10 Friday

11 Saturday

12 Sunday

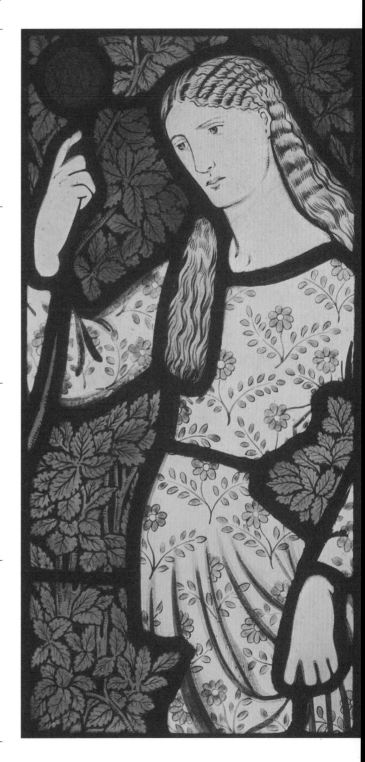

Merchant's Daughter, Edward Burne-Jones, stained and
painted glass, made by Morris, Marshall, Faulkner & Co.,
about 1864

AUGUST

13 Monday

14 Tuesday

15 Wednesday

16 Thursday

17 Friday
New Moon

18 Saturday

19 Sunday
Eid-al-Fitr (end of Ramadân)

Yesso furnishing fabric, Bruce Talbert, figured silk for Warner & Ramm, 1870

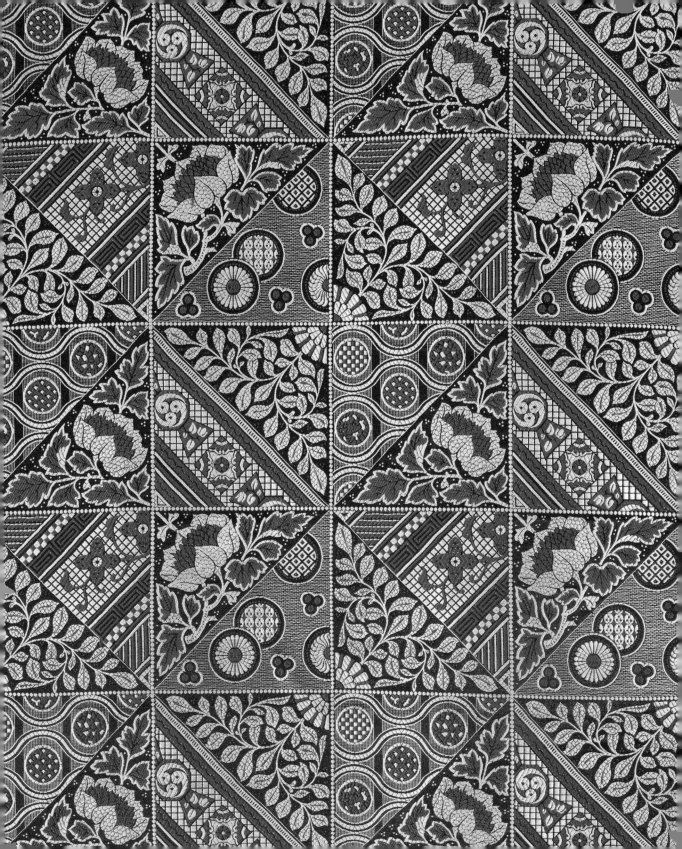

AUGUST

20 Monday

21 Tuesday

22 Wednesday

23 Thursday

24 Friday

25 Saturday

26 Sunday

Figure in Aesthetic Dress, Edward William Godwin,
pen and pencil on paper, 1880

AUGUST • SEPTEMBER

27 Monday Summer Bank Holiday, UK (exc. Scotland)

28 Tuesday

29 Wednesday

30 Thursday

31 Friday *Full Moon*

1 Saturday

2 Sunday

Design for *The Sunflower* wallpaper, Bruce Talbert, watercolour and body colour on paper, 1878

SEPTEMBER

3 Monday

4 Tuesday

5 Wednesday

6 Thursday

7 Friday

8 Saturday

Last Quarter

9 Sunday

Vase, William De Morgan, painted earthenware with a lustre glaze, 1888–98

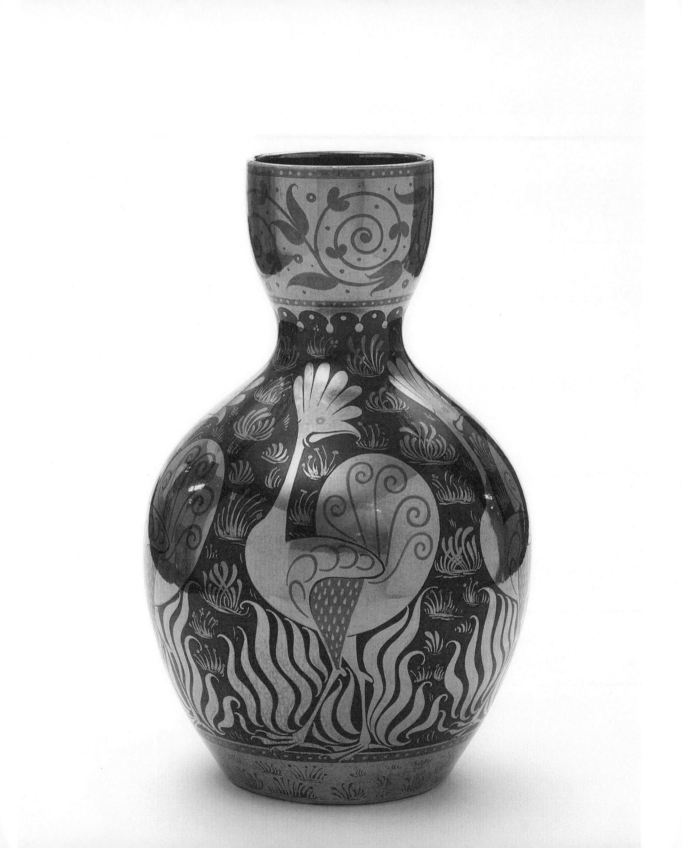

SEPTEMBER

10 Monday

11 Tuesday

12 Wednesday

13 Thursday

14 Friday

15 Saturday

16 Sunday

New Moon

(Left and right) Utrecht Velvet furnishing textile, stamped woollen plush, sold by Morris, Marshall Faulkner & Co., about 1871

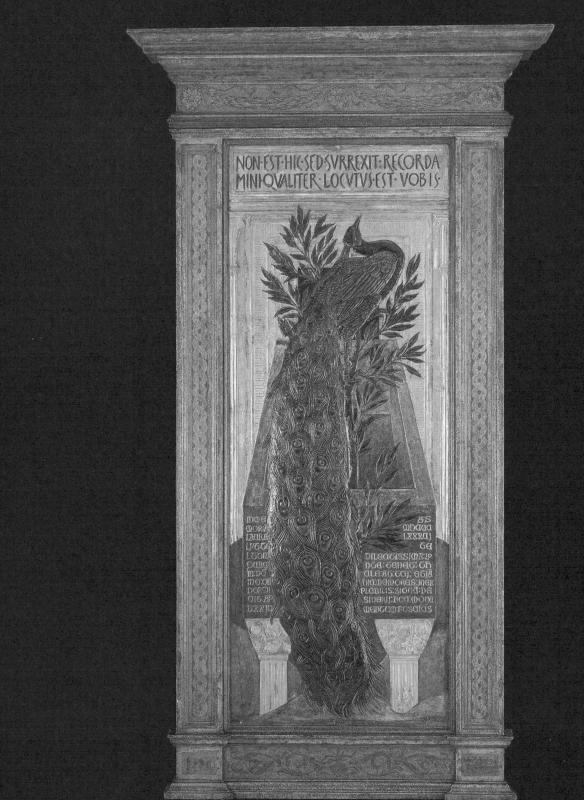

SEPTEMBER

17 Monday Jewish New Year (Rosh Hashanah)

18 Tuesday

19 Wednesday

20 Thursday

21 Friday

22 Saturday *First Quarter*
Autumnal Equinox (Autumn begins)

23 Sunday

Memorial for Laura Lyttleton, Edward Burne-Jones, oil and gilt gesso on wood, about 1886

SEPTEMBER

24 Monday

25 Tuesday

26 Wednesday Day of Atonement (Yom Kippur)

27 Thursday

28 Friday

29 Saturday Michaelmas Day

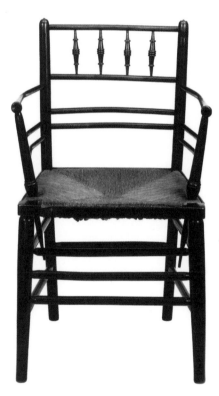

30 Sunday *Full Moon*

Sussex chair, ebonized beech, with turned ornament and a rush seat.
Probably designed by Philip Webb and made by Morris & Co., 1870–90.

OCTOBER

1 Monday

2 Tuesday

3 Wednesday

4 Thursday

5 Friday

6 Saturday

7 Sunday

Furnishing fabric, Bruce Talbert, silk twill satin for Warner & Ramm, about 1875

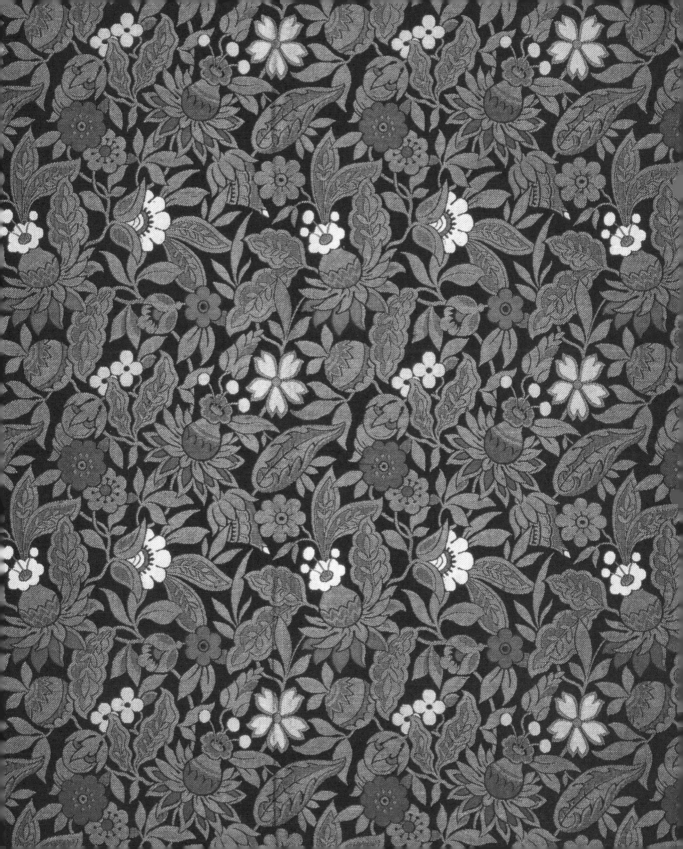

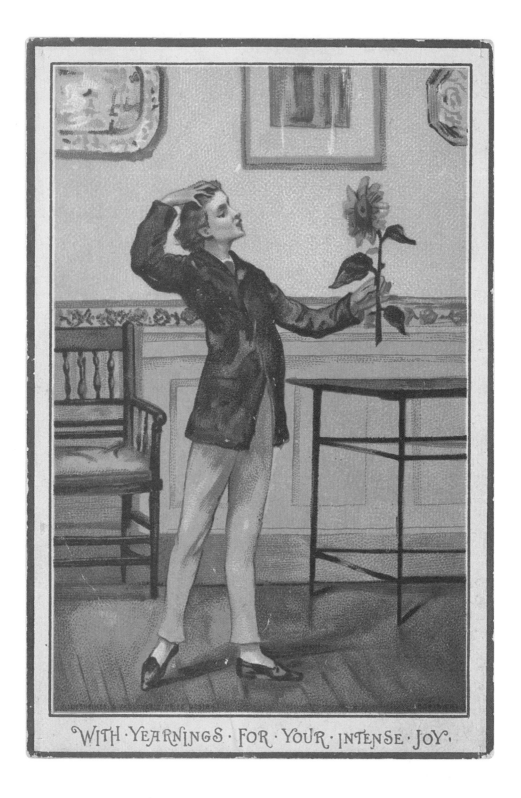

WITH · YEARNINGS · FOR · YOUR · INTENSE · JOY ·

OCTOBER

8 Monday

Last Quarter
Holiday, USA (Columbus Day)
Holiday, Canada (Thanksgiving)

9 Tuesday

10 Wednesday

11 Thursday

12 Friday

13 Saturday

14 Sunday

Aesthetic greetings card, Albert Ludovici Jr., colour lithograph on paper, 1880

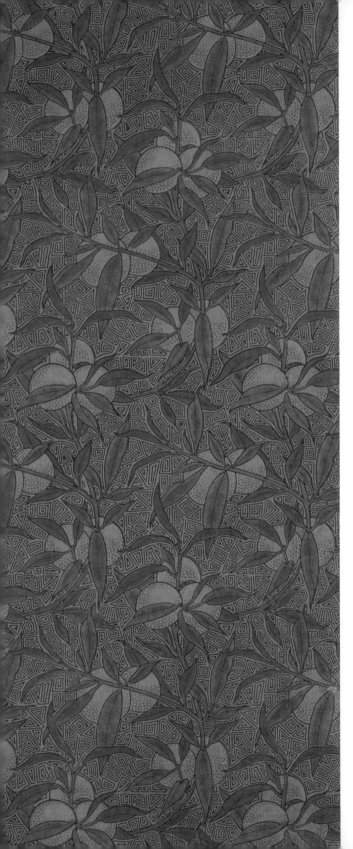

OCTOBER

15 Monday *New Moon*

16 Tuesday

17 Wednesday

18 Thursday

19 Friday

20 Saturday

21 Sunday

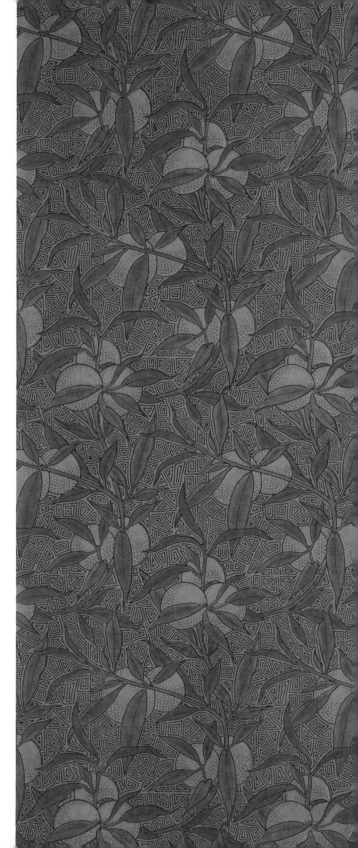

(Left and right) *Pomegranate* wallpaper, Lewis F. Day, colour print from wood blocks, made by Jeffrey & Co., 1874

OCTOBER

22 Monday

First Quarter
Holiday, New Zealand (Labour Day)

23 Tuesday

24 Wednesday

United Nations Day

25 Thursday

26 Friday

27 Saturday

28 Sunday

British Summer Time ends

The Day Dream, Dante Gabriel Rossetti, oil on canvas, 1880

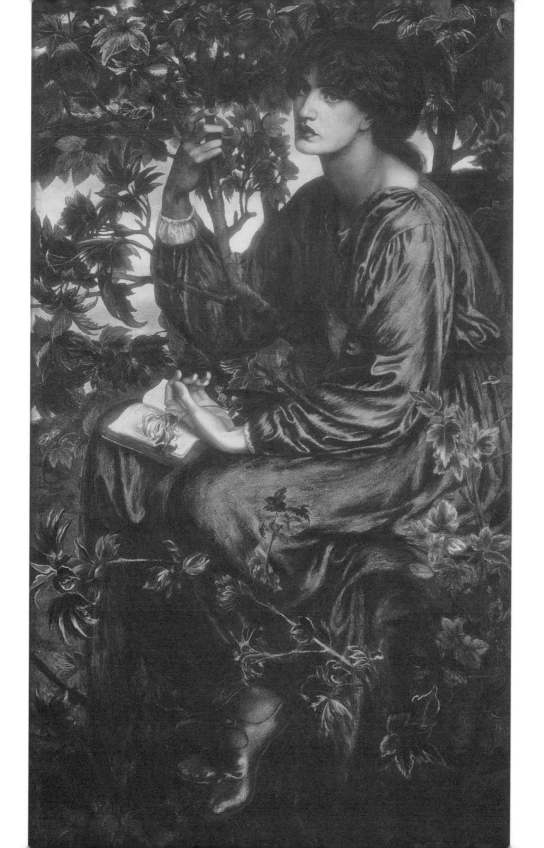

OCTOBER • NOVEMBER

29 Monday

Full Moon
Holiday, Republic of Ireland

30 Tuesday

31 Wednesday

Hallowe'en

1 Thursday

All Saints' Day

2 Friday

3 Saturday

4 Sunday

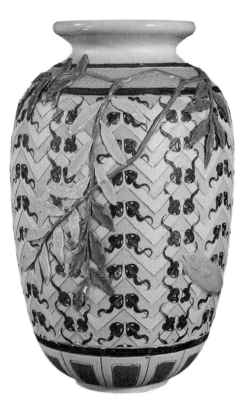

Vase, Harry Barnard, salt-glazed
stoneware, made by Doulton, 1882

"MY LADY'S CHAMBER."

NOVEMBER

5 Monday

6 Tuesday

7 Wednesday *Last Quarter*

8 Thursday

9 Friday

10 Saturday

11 Sunday Remembrance Sunday

Frontispiece to Clarence Cook's *The House Beautiful*, Walter Crane, 1878

NOVEMBER

12 Monday

<div align="right">Holiday, USA (Veterans Day)
Holiday, Canada (Remembrance Day)</div>

13 Tuesday

<div align="right">*New Moon*</div>

14 Wednesday

15 Thursday

<div align="right">Islamic New Year begins (subject to sighting of the moon)</div>

16 Friday

17 Saturday

18 Sunday

<div align="right">Sideboard, Edward William Godwin, ebonized mahogany with silver-plated handles
and inset panels of embossed leather paper, 1867–70</div>

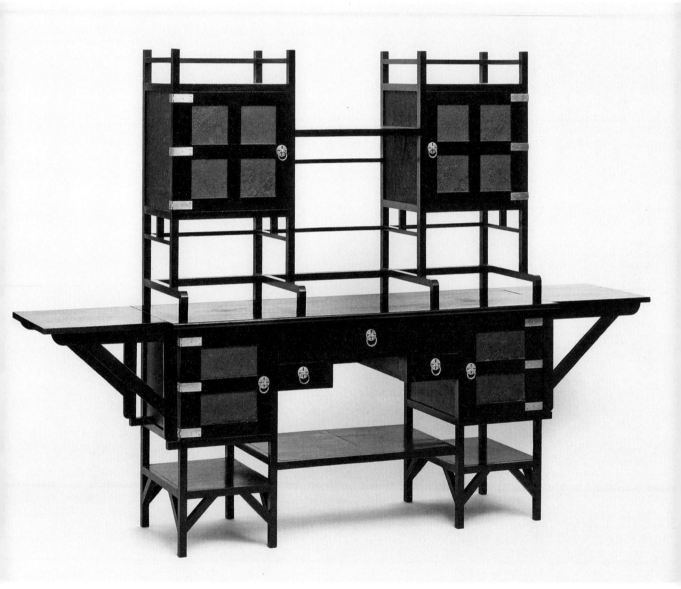

Quality 2SC
Design 3275
Color Destroyed

NOVEMBER

19 Monday

20 Tuesday *First Quarter*

21 Wednesday

22 Thursday Holiday, USA (Thanksgiving Day)

23 Friday

24 Saturday

25 Sunday

(Left and right) Sample from a Japonesque fabric
swatch-book, Edward William Godwin, silk and wool
furnishing fabric for J. W. & C. Ward, about 1870–5

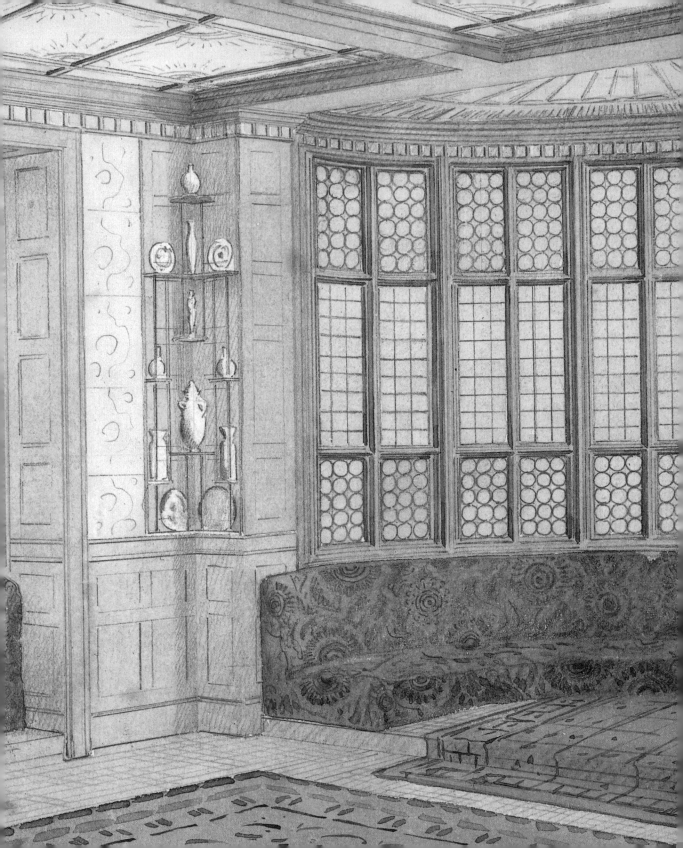

NOVEMBER • DECEMBER

26 Monday

27 Tuesday

28 Wednesday *Full Moon*

29 Thursday

30 Friday St Andrew's Day

1 Saturday

2 Sunday First Sunday in Advent

Design for the billiard room at 1 Holland Park, Thomas Jeckyll, watercolour, about 1870

DECEMBER

3 Monday

4 Tuesday

5 Wednesday

6 Thursday *Last Quarter*

7 Friday

8 Saturday

9 Sunday Hannukah begins

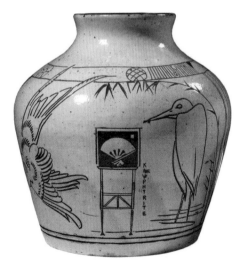

Vase, Edward William Godwin, red earthenware with
sgraffito decoration on cream slip, about 1877

DECEMBER

10 Monday

11 Tuesday

12 Wednesday

13 Thursday *New Moon*

14 Friday

15 Saturday

16 Sunday

The New Woman, Albert George Morrow, poster for the Comedy Theatre, colour lithograph, 1894

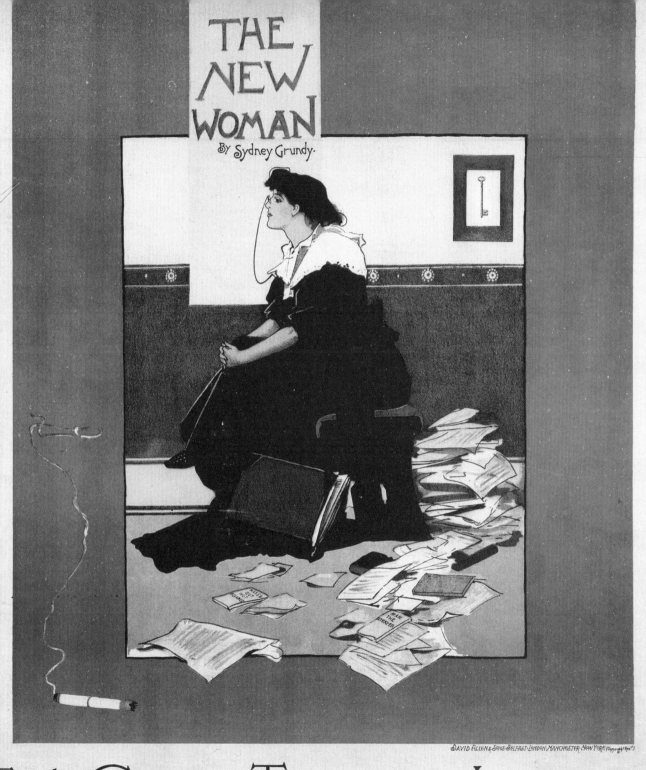

WINTER

DECEMBER

17 Monday

18 Tuesday

19 Wednesday

20 Thursday *First Quarter*

21 Friday Winter Solstice (Winter begins)

22 Saturday

23 Sunday

Winter tile, Kate Greenaway, earthenware, transfer-printed and hand-coloured for T. & R. Boote, 1881–5

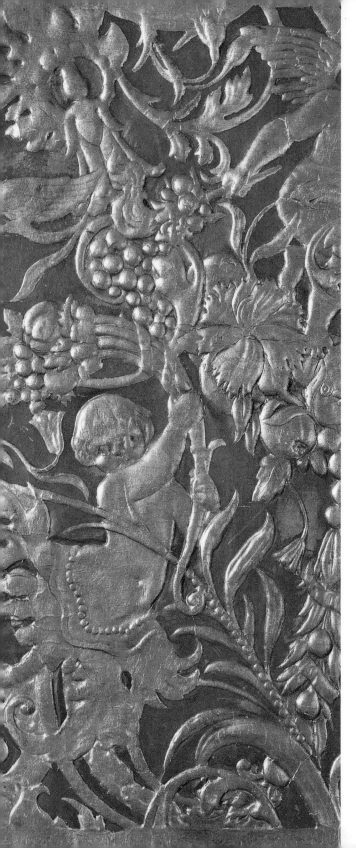

DECEMBER

24 Monday Christmas Eve

25 Tuesday Christmas Day
Holiday, UK, Republic of Ireland, USA, Canada,
Australia and New Zealand

26 Wednesday Boxing Day (St Stephen's Day)
Holiday, UK, Republic of Ireland,
Australia and New Zealand

27 Thursday

28 Friday *Full Moon*

29 Saturday

30 Sunday

(Left and right) Wallpaper, designer unknown. Paper
embossed to simulate leather on a gilt ground,
about 1877–80

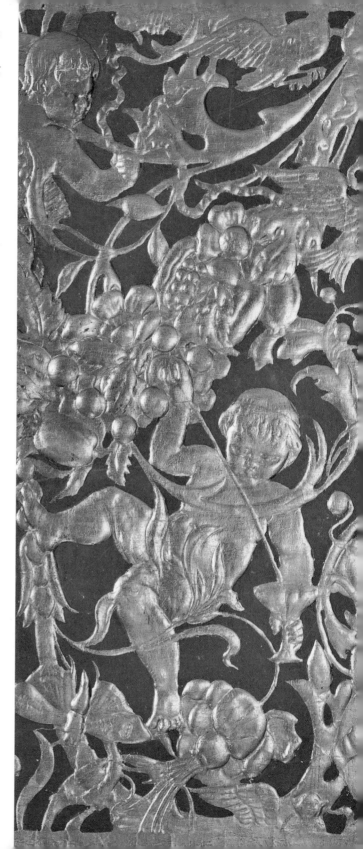

DECEMBER • JANUARY 2013

31 Monday New Year's Eve

1 Tuesday New Year's Day
Holiday, UK, Republic of Ireland, USA, Canada,
Australia and New Zealand

2 Wednesday Holiday, Scotland and New Zealand

3 Thursday

4 Friday

5 Saturday Last Quarter

6 Sunday Epiphany